Savan

and the State of GEORGIA

It's old with lots of new!

It's fun

and friendly, too!

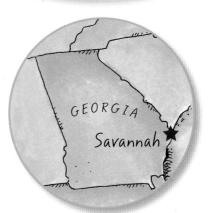

he places where you live and visit help shape who you become. So find out all you can about the special places around you!

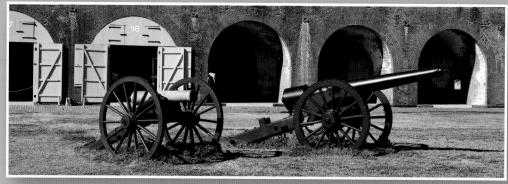

You can see Civil War cannons at the Fort Pulaski National Monument

CREDITS

Series Concept and Development

Kate Boehm Jerome

Design

Steve Curtis Design, Inc. (www.SCDchicago.com), Roger Radke, Todd Nossek

Reviewers and Contributors

Leah M. Colby, educator, Savannah-Chatham County Public Schools; Connie Bodner, PhD, senior researcher; Judy Elgin Jensen, research and production; Mary L. Heaton, copy editor

Photography

Cover(a), Back Cover(a), i(a), By The Numbers (b), Dramatic Days (b), xvi(c) © David Davis/Shutterstock; Cover(b), Back Cover(b), i(b) © Marty Ellis/Shutterstock; Cover(c), Dramatic Days (c), xvi(e, g) © Travel Bug/Shutterstock; Cover(d), iii, By The Numbers (a), Strange But True (a, b, c) by Genevieve Bailey; ii © JASON TENCH/Shutterstock; Spotlight (background) © Filipe B. Varela/Shutterstock; Spotlight (a) © Jung-Pang Wu/Shutterstock; Spotlight (b) Courtesy the Savannah Sand Gnats; By The Numbers (c) U.S. Army Corps of Engineers Digital Visual Library/from Wikipedia; By The Numbers (d) © WilleeCole/Shutterstock; Sights and Sounds (a) © Tatiana Morozova/Shutterstock; Sights and Sounds (b), xvi(a) © Jill Lang/Shutterstock; Sights and Sounds (c) © K Chelette/Shutterstock; Sights and Sounds (d) © Harris Shiftman/Shutterstock; Sights and Sounds (e) © Francis Bossé/Shutterstock; Sights and Sounds (f) Courtesy Massie School; Sights and Sounds (g) © Louisanne/Shutterstock; Marvelous Monikers (a), xvi(h) Photo Courtesy of Smithfield (recipe specially prepared and created by Paula Deen for Smithfield); Marvelous Monikers (b) © RiverNorthPhotography/iStockphoto; Marvelous Monikers (c) © Alan Tobey/iStockphoto; Marvelous Monikers (d), Dramatic Days (a) by Shawn Latta; xvi(b) © Jack schiffer/Shutterstock; xvi(d) © laszlo a. lim/Shutterstock; xvi(f) © Daniel Hebert/Shutterstock; xvi(inset) Photo by Steve Curtis, Bird Girl Sculpture by Sylvia Shaw Judson (Sculptor)

Illustration

i © Jennifer Thermes/Photodisc/Getty Images

Copyright © 2011 Kale Boehm Jerome. All rights reserved. No part of this book may be used or reproduced in any manner without written permission except in the case of brief quotations embodied in critical articles and reviews.

ISBN 978-1-4396-0091-7

Library of Congress Catalog Card Number: 2010935892

Published by Arcadia Publishing, Charleston, SC For all general information contact Arcadia Publishing at:

Telephone 843-853-2070 Fax 843-853-0044

Email sales@arcadiapublishing.com
For Customer Service and Orders:
Toll-Free 1-888-313-2665

Visit us on the Internet at www.arcadiapublishing.com

Table of Contents

Savannah

Spotlight on Savannah
By the Numbers
Sights and Sounds
Strange But True
Marvelous Monikers
Dramatic Days

Georgia

What's So Great About This State
The Land
Mountains, Valleys, and Plateaus
Piedmont and Coastal Plains
Rivers and Lakes
The History10
Monuments12
Museums 14
Plantations16
The People
Protecting20
Creating Jobs22
Celebrating24
Birds and Words
More Fun Facts
Find Out More
Georgia: At a Glance

Spotlight Sevennen

Savannah is a historic port city that sits on the banks of the Savannah River. It was established in 1733, making it the oldest city in Georgia.

How many people call Savannah home?

The population within the city limits is around 140,000. But the metropolitan area (the city and surrounding area) is home to more than 340,000 people.

Is there an important military presence around Savannah?

Absolutely! Hunter Army Airfield has one of the Army's longest runways. Fort Stewart is the largest Army installation east of the Mississippi.

What's one thing every kid should know about Savannah?

Savannah was a planned city.
Its founder—James Edward
Oglethorpe—laid the city out
in a grid pattern of twenty-four
squares with room for wide
streets and shady trees.

The mascot of the Savannah Sand Gnats minor league baseball team is Gnate the Gnat!

By The Numbers

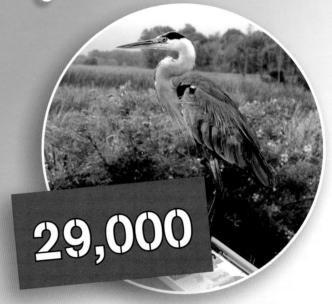

The Savannah National Wildlife Refuge has more than 29,000 protected acres. The refuge, which includes land on both the South Carolina and Georgia sides of the Savannah River, is located just upriver from the city of Savannah.

That was the year the Forsyth Park Fountain was added to Forsyth Park, the largest and oldest park in Savannah.

The Talmadge Memorial cable-stayed bridge that spans the Savannah River provides 185 feet of vertical clearance at high tide for the oceangoing ships that pass beneath it.

Every March 17, hundreds of thousands of people celebrate St. Patrick's Day in Savannah. It's one of the largest celebrations of the Irish in the country!

More Numbers!

re	1 40,0	IRBS PER S		" acres found at	the
		The number of Bamboo Farm	"green space	irdens—part of	the UGA
5	MANUSCRIPT CONTRACTOR OF THE PROPERTY OF THE P	Bamboo Farii	odoneion		
SI	Y	Cooperative E	XIGHSTOTH	left its home po	rt in Savan
		The year the	SS Savannan	1922AV VASSE	to cross th

The year the SS Savannah left its home port in Savannah to become the first steam-powered vessel to cross the Atlantic Ocean.

	Atiannic Goodin	estourant) first opened
	The year the Pirates' House (still to serve food and drink to sails	a restaulant) met en ors—including pirates!
1753	to serve food and drillk to suite	

Savannah: SIGNIS SOUMANIS

Hear

...wonderful music at the Savannah Music Festival. Each spring amazing artists (from classical to jazz) perform at the festival during a city-wide celebration. It's the largest musical arts event in Georgia and showcases both national and international musical traditions.

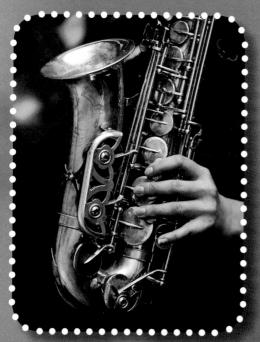

Sme]]

...the lovely scent of the flowers in Forsyth Park's Fragrant Garden. Signs, including ones in Braille for the visually impaired, identify the plants for visitors.

...the fresh pralines and other tasty food made every day in the River Street restaurants and shops.

See

... a real fighter jet while you learn about aviation history at the Mighty Eighth Air Force Museum.

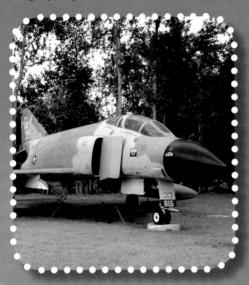

... a nineteenth century classroom at the Massie Heritage Center, which honors Savannah's first public school—opened in 1856!

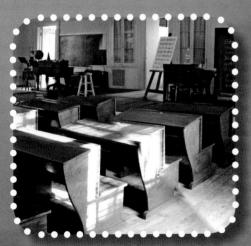

Explore

...the Oatland Island Wildlife Center. You can see live animals, like alligators and rare panthers, that are native to Georgia. And don't forget to look up! Interesting birds, like the Eastern Screech Owl, perch at the center, too.

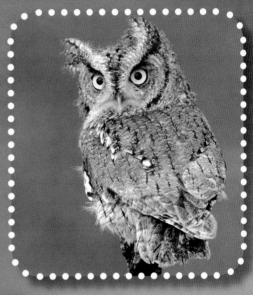

...the ArtZeum at theTelfair"s Jepson Center for the Arts. Interactive displays make art come alive and interesting studio classes are available to further spark your creativity.

Sights and Sounds

SIRINGE

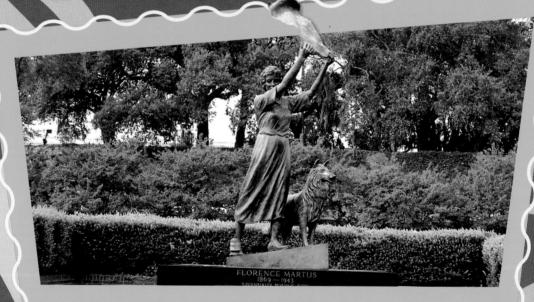

SOUTHERN HOSPITALITY

The Waving Girl Statue stands in Savannah's riverfront Morrell Park.
It's a tribute to Florence Martus, the Elba Island lighthouse keeper's sister. Florence waved a welcome to every ship entering the Savannah port—for an amazing forty-four years!

GHOST TOURS

Popular ghost tours in Savannah take people to places where ghosts are supposed to appear. The Bonaventure Cemetery (more than 160 years old) is the final resting place of many long-ago residents with interesting stories. Are there really ghosts in Savannah? You be the judge!

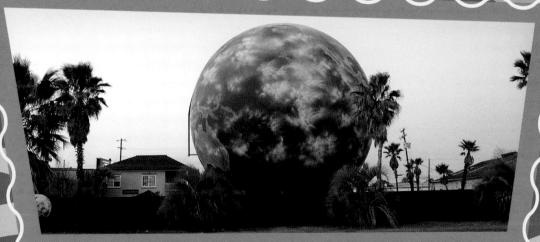

A GLOBAL VIEW

A huge 60-foot-diameter tank in Savannah that was originally built in the 1950s to store natural gas is painted to look like (what else?) a globe! To complete the view, the mailbox for this address (look in the lower left corner) is a smaller round object—the Moon!

Savannah

arvelous onikers

What's a moniker? It's another word for a name...and Savannah has plenty of interesting monikers around town!

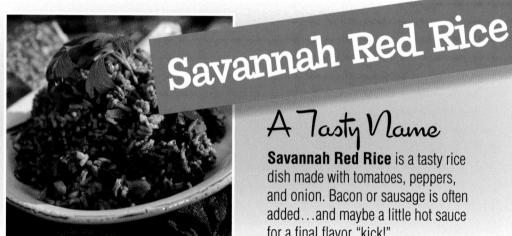

A Tasty Name

Savannah Red Rice is a tasty rice dish made with tomatoes, peppers. and onion. Bacon or sausage is often added...and maybe a little hot sauce for a final flavor "kick!"

A Cotton-Counting Name

Factors Walk includes a series of alleys, walkways, and iron bridges that "factors." or cotton brokers, used to walk when the cotton business was king in Savannah.

Factors Walk

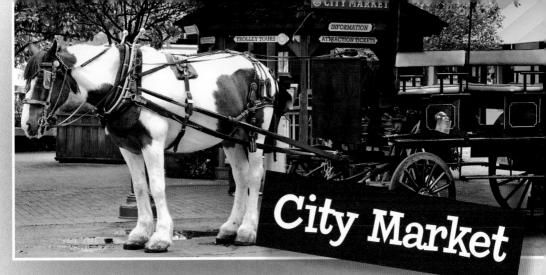

A Marketable Name

The original **City Market** opened as a fish and produce market in 1755. Today's City Market is built in the same area and has everything from restaurants and art galleries to trolley and carriage rides.

A Founder's Name

Juliette Gordon Low (better known as "Daisy" in Savannah) founded Girl Scouts of the USA. She was born and raised in Savannah.

Tree City USA

A Green Nickname

Savannah takes great pride in its beautiful trees and plants throughout the city. The National Arbor Day Foundation has consistently recognized the city as a "**Tree City USA**."

Marvelous Monikers

Savannah: ANAIIC ASS

A Terrible Epidemic!

In the 1820s, the city of Savannah suffered a severe outbreak of a disease called yellow fever. More than seven hundred people died. Additional outbreaks in 1854 and 1876 left thousands more people dead. Luckily, yellow fever is now eliminated in North America so cities like Savannah no longer need fear this dreaded illness.

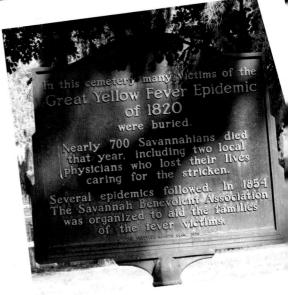

Break!

Major General William T. Sherman's infamous "March to the Sea" through Georgia ended in Savannah.

However, rather than destroying the beautiful captured through Georgia ended in Savannah.

However, rather than destroying the beautiful captured to the president Abraham Lincoln in which a telegram to President Abraham Lincoln in which a telegram to him "as a Christmas gift, the City of a telegram to him "as a Christmas gift, the City of a telegram to him "as a Christmas gift, the City of a telegram to him savannah, General Sherman he presented to him savannah, General Sherman savannah..." While in Savannah, General Sherman made his headquarters at the Green-Meldrim House, which still stands today.

In 1955 a group of women from Savannah saved the Davenport House from destruction. This effort gave rise to the Historic Savannah Foundation that has since saved many of Savannah's old buildings. Today, the entire downtown district of Savannah is a National Historic Landmark.

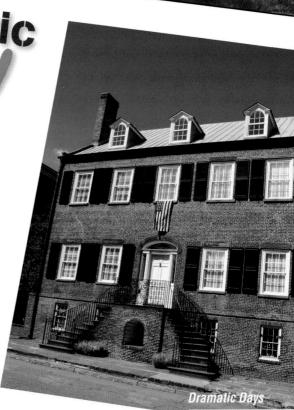

There is a lot to see and celebrate...just take a look!

CONTENTS

Landpag	es 2-9
Historypag	
People	
And a Lot More Stuff!pag	

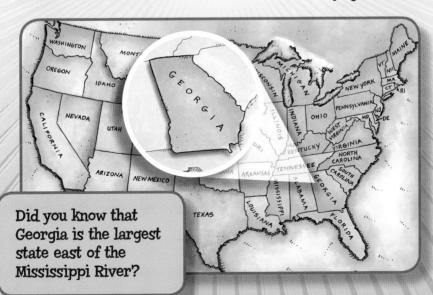

What's So Great About This State?

Well, how about... the land!

From the Mountains...

You won't get bored when you travel around the state of Georgia! Why? The state has five (yes, five!) different regions. Each region has landforms, plants, and animals that make it special.

The very northern part of the state has mountains, valleys, and plateaus. Thick forests and cool lakes are in this region. Water twists and turns through rivers like the wild Chattooga. But soon the tall mountains give way to the rolling hills of the Piedmont region. This is where most of the state's biggest cities are found.

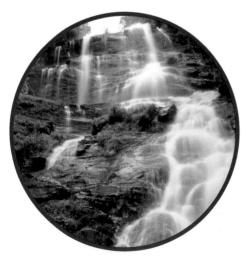

One of the tallest waterfalls east of the Mississippi River can be found in northern Georgia's Amicalola Falls State Park.

Atlanta, the capital city of Georgia, is located in the Piedmont region.

Keep on traveling south and you will find the Coastal Plains. This region makes up more than half the state. The upper part of this region has great soil. So this is where the tasty "P" crops grow. What are they? Peanuts, peaches, and pecans, of course!

The lower part of the Coastal Plains gets...well, lower! This means marshes and swamps begin to appear. Keep going south and east to find sandy beaches. That's right! The eastern part of Georgia has the Atlantic Ocean as its border.

Soil in the Coastal Plains grows tasty peaches.

The Savannah River flows past the city of Savannah toward the Atlantic Ocean.

Mountains, Valleys, and Plateaus, Plateau Plateau Plateau Prince and Valley APPALACHIAN PLATEAU P

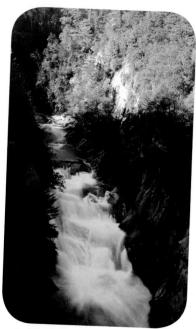

Tallulah Gorge State Park is in the Blue Ridge region.

Do you like high places? Then visit the northern part of Georgia. It has three regions: the Blue Ridge Mountains, the Ridge and Valley region, and the Appalachian Plateau.

What's up in the Blue Ridge region?

Just about everything! After all, this northeastern area of the state is part of the Blue Ridge Mountain range. Brasstown Bald—the highest point in Georgia—is here.

A hike through the Blue Ridge region is a back-to-nature treat. Water rushes over waterfalls. Thick forests hide black bears, turkeys, and whitetail deer.

What can I see in the Ridge and Valley region?

Lots of trees line the sides of the steep ridges. But there's good soil in many of the valleys. You can also find fossils of ancient fish here. Millions of years ago, the area was completely covered in water!

The Ridge and Valley region makes up most of the northwestern part of the state.

...except for that little Plateau region!

There's a tiny region in the far northwest part of Georgia with a big name. It's called the Appalachian Plateau. (A plateau is a high,

level area.) One of the flat-topped mountains that form this plateau is called Lookout Mountain.

It's so long it stretches into the neighboring states of Alabama and Tennessee!

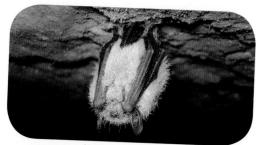

Bats hang out in the many caves found in northwest Georgia.

PEGMONS ANG COSTAL PLANS COASTAL PLANS C

The famous Masters Golf Tournament is in the Piedmont region in Augusta, Georgia.

The mountains of north Georgia slowly give way to the hilly area of the Piedmont. Below the Piedmont are the Coastal Plains with flatlands, marshes, and swamps.

What's so special about the Piedmont region?

Well, it has lots of trees. Short-leaf and loblolly pines are in this region. So are oak, hickory, and many other trees.

The Piedmont also has hard rock called granite. The grandest example of granite is at Stone Mountain. This mountain is two miles long and a mile wide.

The Piedmont region ends at the Fall Line. The Fall Line is not a real line, of course. It's just an area where the fast-moving rivers of the Piedmont "fall" onto the lower land of the Coastal Plains.

What can I see in the Coastal Plains?

The largest swamp in the United States! The Okefenokee covers 700 square miles and stretches from southeastern Georgia into northern Florida. Okefenokee is a Seminole name. It means "land of the trembling earth."

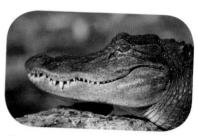

Got gators? The Okefenokee Swamp has plenty!

Why does the land seem to move? Layers of peat moss form on water. Trees and other plants grow in the peat moss. The land looks solid, but it's not. Peat moss can move or cave in. You have to watch your step!

Don't forget the beaches!

To the east the Coastal Plains end in beaches and barrier islands. These are lots of fun—and they protect the land along the coast.

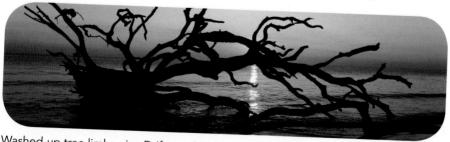

Washed-up tree limbs give Driftwood Beach on Jekyll Island a spooky look at sunrise.

Rivers

Water flows through all the regions of Georgia. The state has thousands of miles of rivers and lots of lakes, both big and little.

Why are the lakes and rivers so special?

Lakes and rivers provide recreation, transportation, food, and habitats! Some of the lakes in Georgia weren't formed by nature but are man-made. Lake Lanier is an example. It has over 600 miles of shoreline. That's a lot of space for fishing, boating, and camping.

What can I see at the lakes and rivers?

Striped bass, rainbow trout, and bluegill! These are just some of the colorful fish swimming in Georgia's lakes and rivers.

Border lines

Some of the rivers in Georgia have a special job. They form borders with other states.

The Chattooga, Tugaloo, and Savannah Rivers each share part of the border with South Carolina. On the other side of the state, the Chattahoochee River forms part of the border between Georgia and Alabama.

The St. Mary's River forms part of the boundary between Georgia and Florida. It's a blackwater river. Why? Tons of leaves and other plant parts fall into the river to rot. Stuff (called tannins) from this rotting plant material makes the river water look dark.

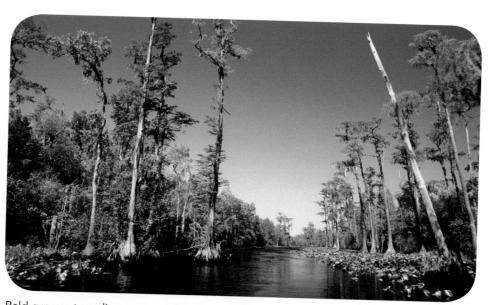

Bald cypress trees line canoe trails in this blackwater river in the Okefenokee National Wildlife Refuge.

Well, how about... the history

Tell Me a Story!

The story of Georgia began thousands of years ago. At that time, many Native Americans made their homes throughout the state.

By the 18th century, the Creeks and the Cherokee were the largest Native American groups in Georgia. Spanish explorers had come to Georgia. But James Oglethorpe, a British doctor, settled the colony of Georgia in 1733. He was able to do this with the help of many Native Americans. Tomochichi, the chief of a small Yamacraw tribe, became Oglethorpe's friend and helped him build the city of Savannah. A woman named Mary Musgrove had a Creek mother and an English father. Since she could speak both languages, she helped leaders on both sides keep the peace.

This statue in Calhoun honors Sequoyah. He created the first Cherokee language alphabet. In 1838, the Cherokee were forced out of Georgia. The thousand-mile journey to Oklahoma cost many lives. It is now remembered as the "Trail of Tears."

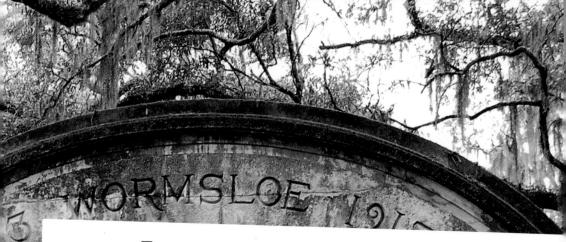

...The Story Continues

Eventually, Georgia became home to many other groups, including European American settlers and African Americans. Many battles for independence were fought in Georgia. Civil War battles, in particular, caused great struggle and loss.

But history isn't always about war. Georgians have always been educators and inventors. They have painted, written, sung, and built. Many footprints are stamped into the soul of Georgia's history. And you can see proof of this all over the state!

Georgia was the last of the 13 original British colonies. The state had a strong presence in the Revolutionary War.

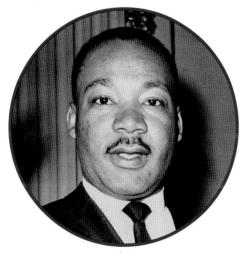

Dr. Martin Luther King Jr. was a civil rights leader born in Atlanta. He received the Nobel Peace Prize for his work.

Monments

Fort King George Historic Site in Darien, Georgia

Monuments and historic sites honor special people and events. The Fort King George Historic Site helps people remember the first English settlement on the coast of Georgia.

Why are Georgia monuments so special?

That's an easy one! There were many special people who helped build the state of Georgia. Some were famous soldiers and politicians. Others were just ordinary people who did special things to shape the state of Georgia—and the nation.

What kind of monuments can I see in Georgia?

There are many different kinds. From statues to bridges, almost every town has found some way to honor a historic person or event. Even street signs often show the name of someone special.

Where are monuments placed?

Anywhere! The images of three Confederate leaders who served in the Civil War are carved into the side of Stone Mountain near Atlanta.

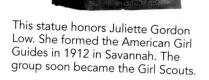

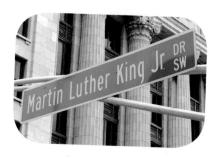

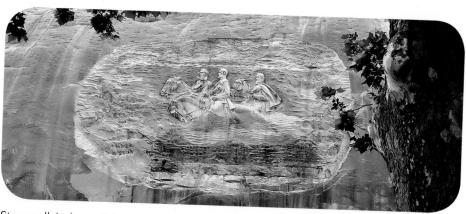

Stonewall Jackson, Robert E. Lee, and Jefferson Davis are carved in the rock at Stone Mountain Park in Stone Mountain, Georgia.

Museums

You can see a bronze hadrosaur sculpture at the new Dinosaur Entrance Plaza at the Fernbank Museum of Natural History.

Museums don't just tell you about history—they show you things! How? Artifacts, of course! Museum artifacts are objects or models of objects. Either way, they make history come alive!

Why are Georgia's museums so special?

Amazing museum exhibits tell the story of the state. The Tybee Island Light Station tells a 270-year-old story. General Oglethorpe (the founder of Georgia) decided to build a tall mark to help sailors find the mouth of the Savannah River. So the first lighthouse was built on Tybee in 1736. But due to storms and other damage, two more lighthouses have been built and replaced. The lighthouse that shines on Tybee now is the fourth one built on the island!

What can I see in a museum?

An easier question to answer might be "What can't I see in a museum?" There are thousands of items in different museums across the state. Do you want to know about home run hitter Henry "Hank" Aaron? The Georgia Sports Hall of Fame and Museum in Macon, Georgia, is loaded with sports stories. Or maybe you'd like to know more about the 39th President of the United States. Then the Jimmy Carter Library and Museum in Atlanta is the place you'll want to see.

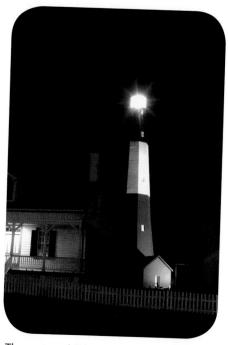

The restored Tybee Island Light Station has 178 stairs.

Learn the history of Georgia's Cherokee Nation at the New Echota Historical Site in Calhoun, Georgia.

The Brick House on the Calloway Plantation was completed in 1869.

The Brick House on the Calloway Plantation was made from the same kind of red Georgia clay that it stands on. The house is in its nearly original condition. What does that mean? No plumbing, no electricity, no heating, and no air conditioning!

Why are plantations special? (...and what is a plantation, anyway?)

Plantations were large estates or farms. Crops such as rice and cotton were grown on plantations. Enslaved Africans, and, later, enslaved African Americans, did most of the work on a plantation.

Today, many plantations tell the shared history of our country. All have interesting stories of race, families, and sacrifice.

Skilled blacksmiths made horseshoes on plantations.

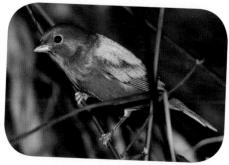

You can see more than plantations on the Colonial Coast Birding Trail! More than 300 different kinds of birds have been spotted along this trail. The painted bunting is one of them.

What can I see if I visit a plantation?

Georgia has plenty of antebellum plantations. Antebellum means "before the war." Which war? The American Civil War that was fought from 1861 to 1865.

Many antebellum plantations show you what life was like 150 years ago. Some showcase the work of enslaved people who became skilled workers. Other plantations have been changed and brought up to date. Now an old plantation might also be a new hotel.

...and there's more!

Cotton grew well on plantations in the southern and middle parts of Georgia. But rice was the crop to plant along the coast. You can see some of these rice plantations when you travel the 100-mile-long Colonial Coast Birding Trail.

What's So Great About This State?

Well, how about... the people!

Enjoying the Outdoors

More than nine million people call Georgia their home. So it should be no surprise that there are lots of different viewpoints in the state. Yet Georgians still rally together to form a very friendly group. They are known for their Southern hospitality. This helps explain why 50 million tourists visit the state each year!

A mild climate in Georgia allows people to enjoy the outdoors all year round. Fishing, boating, hiking, swimming—the list of things that Georgians like to do goes on and on!

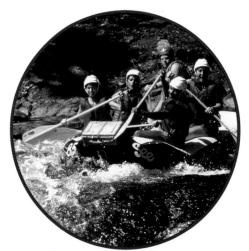

Whitewater rafting on the Chattooga River is lots of fun!

Football stadiums swell with fans to watch any Georgia team!

Sharing Traditions

The people of Georgia celebrate many different heritages and traditions. The Gullah culture is one example. It was formed by enslaved people who were brought to Georgia. A combination of English and African words developed into a special Gullah language. This Gullah language and culture is still celebrated today—especially on the barrier islands off the coast of Georgia.

Did you ever wonder what a Civil War battle was like? Georgians often re-create battles from different wars to honor the memory of brave soldiers. Cooking is another way to pass on traditions. Great Southern food recipes are cherished family keepsakes!

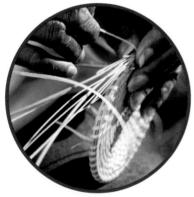

Weaving sweetgrass baskets is one Gullah tradition that has become a well-respected art.

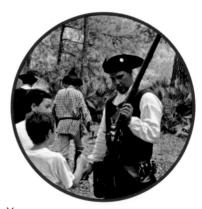

You can see reenactments of battles that were fought long ago at the Wormsloe Historic Site in Savannah.

Protecting

The Georgia Aquarium in Atlanta is the world's largest indoor aquarium. Aquatic animal conservation and research are among its major goals.

Protecting Georgia's natural resources is a full-time job for many people!

Why is it important to protect Georgia's natural resources?

The many different environments in Georgia help shape its character. In the rugged northeast, tall cliffs stand guard over fast-moving rivers in the Tallulah Gorge. As you move south, rolling hills, red clay, and farmland cover more than half the state. Finally, marshes and blackwater rivers give way to miles of beaches along the coast and barrier islands. All these different environments provide habitats for the many different plants and animals in the state. That's called biodiversity—and it keeps the environments balanced and healthy.

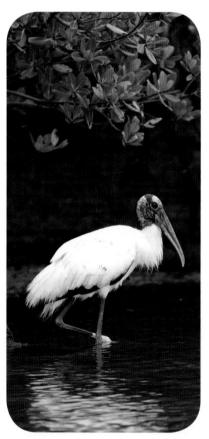

The endangered wood stork can be found in Georgia.

Who protects these resources?

It takes a lot of groups to cover it all. The U.S. Fish and Wildlife Service is a national organization. The Georgia Department of Natural Resources and the Georgia State Parks Service are state organizations. Many smaller groups exist as well.

And don't forget...

You can make a difference, too! It's called "environmental stewardship"— and it means you are willing to take personal responsibility to help protect Georgia's natural resources. It's a smart choice for a great future!

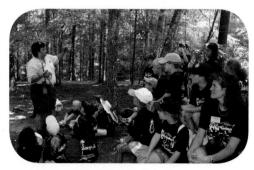

Learn about a forest habitat at Red Top Mountain.

Many people work at Atlanta's Hartsfield-Jackson International Airport. It's the busiest airport in the world.

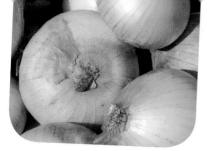

Vidalia onions are a favorite vegetable! They are grown only in southern Georgia.

Chefs are needed to prepare food for the tourists in Georgia.

Military training is hard work!

are newer to the state. These include transportation, medicine, and filmmaking, to name a few.

Why is Georgia a good place to work?

Great natural resources and great people! These two things help businesses grow.

What kinds of jobs are available throughout the state?

Farming is big. Cotton, peaches, pecans, peanuts, and onions are just some of the crops grown in Georgia. The many trees in Georgia also support a large timber industry.

The transportation industry provides many jobs, too. Think of all the people it takes to move 90 million people through Atlanta's airport each year!

Manufacturing, or making things, is common. Another big industry is the service industry. Many jobs are needed to help tourists sightsee, eat, and relax!

Don't forget the military!

The Air Force, Army, Marines, Navy, and Coast Guard can all be found in the state. Georgians have a great respect for all the brave men and women who serve our country.

celeprating A Ferris Wheel lights the night at the North Georgia State Fair.

The people of Georgia work hard. But they also know how to have fun. Georgians celebrate at two state fairs each year! The Georgia State Fair is in Macon. The North Georgia State Fair is in Marietta.

Why are Georgia festivals and celebrations special?

Celebrations and festivals bring people together. Some celebrate music and cooking. Others celebrate arts and crafts. All celebrate the people of Georgia and their talents.

What kind of celebrations and festivals are held in Georgia?

Too many to count! But one thing is for sure. You can find a celebration for just about anything you want to do.

Do you like to eat barbecue? Teams compete in a cook-off for the best barbecue at the National Barbecue Festival in Douglas, Georgia.

Would you rather dance and listen to music? You can do both at the La Fiesta del Pueblo in Tifton, Georgia. This festival celebrates Hispanic culture in southern Georgia.

You can even celebrate on the water! Shrimp boats turn into beautiful floats for the Blessing of the Fleet festival in Darien, Georgia.

Don't forget about the Mud Pit Belly Flop Contest!

Yes, it's true! This contest is just one of the very entertaining events at the Redneck Games in East Dublin, Georgia.

You can hear great jazz at the Music Festival in Savannah.

Do you like watermelon? There is always plenty to enjoy at the Watermelon Days Festival in Cordele, Georgia.

B-Hods and OF S

What do all the people of Georgia have in common? These symbols represent the state's shared history and natural resources.

State Bird
Brown Thrasher

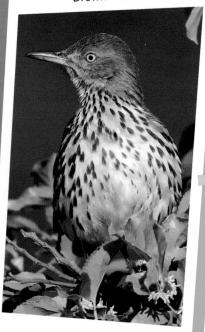

State Flower Cherokee Rose

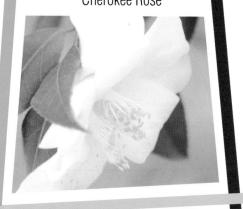

State Tree

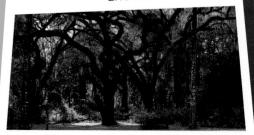

State Fruit

Peach

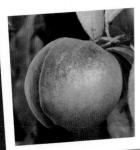

Peaches are also the state fruit of South Carolina and Alabama! However, the state that produces the most peaches in the United States is California!

State Reptile Gopher Tortoise

Gopher Tortoise burrows can provide homes to more than 350 other species of animals!

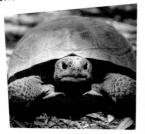

State Flag Adopted 2003

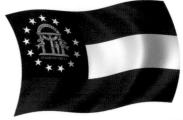

State Crop

Georgia grows more peanuts than any other state!

State Insect

State Butterfly Tiger Swallowtail

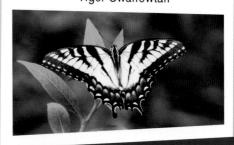

Want More?

Statehood—January 2, 1788 State Capital—Atlanta State Nickname—Peach State State Song—"Georgia on My Mind" State Game Bird—Bobwhite quail State Wildflower—Azalea
State Fish—Largemouth bass
State Amphibian—Green tree frog
State Shell—Knobbed whelk
State Gem—Quartz

More Facts

More

Here's some more interesting stuff about Georgia.

That's BIG!

Because it has an area of more than 58,000 square miles, Georgia is known as the "Empire State of the South."

An Original

Colonized in 1732 by James Edward Oglethorpe, Georgia was the last of the original thirteen English colonies.

Fit For a King

The state of Georgia was named after King George II of Great Britain.

Border Pals

Tennessee and North Carolina are neighbors to the north. In the south, Georgia runs into Florida. To the west of Georgia is Alabama. To the east is the state of South Carolina and the Atlantic Ocean.

Cotton Cleaner

Eli Whitney developed the cotton gin in Georgia in 1793. The machine made cleaning cotton much easier.

Rock the Vote

Georgia was the first state to allow 18-year-olds to vote.

Lights, Camera, Action

Some movies made in Georgia include Forrest Gump, Driving Miss Daisy, and Smokey and the Bandit.

Capital Moves

Before Atlanta took the title in 1868, Georgia had four other capital cities. They included **Savannah** (1733-1786), **Augusta** (1786-1795), **Louisville** (1796-1806), and **Milledgeville** (1807-1868). A Long Hike

The Appalachian Trail starts in north Georgia and ends in the state of Maine.

Gold Rush

Each fall the small town of **Dahlonega**, **Georgia** has a festival. It celebrates the discovery of gold in Dahlonega in 1828.

Tree Spirits

Sad faces are carved into some of the oak trees on **St. Simons Island, Georgia**. Many of the faces remind people of sailors who lost their lives at sea.

Famous Fizz

John S. Pemberton invented Coca-Cola in Georgia in 1886. The drink was first sold in a store in **Atlanta**.

A Best Seller

Atlanta native Margaret Mitchell wrote one of the most famous books of all time. *Gone With the Wind* is a story set in the Civil War. It took Ms. Mitchell about ten years to finish the book!

Locals call it "The Forks"

In southern Georgia, the **Oconee** and **Ocmulgee Rivers** become the **Altamaha River** (the largest river in Georgia).

Old School

The University of Georgia at Athens is the oldest public university in the United States The state voted to charter the university in 1785.

Chart Busters

The man who wrote the song "Jingle Bells," James Lord Pierpont, came from **Valdosta, GA**. Ray Charles, a native of **Albany, Georgia** wrote the hit song "Georgia on My Mind."

Insect Troubles

Between 1915 and 1923, a little insect made big trouble for cotton farmers. During this time, the boll weevil destroyed more than one third of the cotton crops in Georgia.

A Refreshing River

The **Chattahoochee River** isn't just for fishing and rafting. This river provides drinking water to half the people in Georgia.

A Very Nutty Place

The area around **Albany, Georgia** is known as the "pecan capital of the world" because of the many pecan trees there.

Find Out More

There are many great websites that can give you and your parents more information about all the great things that are going on in the state of Georgia!

State Websites
The Official Website of the
State of Georgia
www.ga.gov

Georgia State Parks www.gastateparks.org

The Official Tourism Site of Georgia www.exploregeorgia.org

Museums/Albany
Albany Civil Rights Movement
Museum
www.albanycivilrightsinstitute.org

Atlanta

Fernbank Museum of Natural History www.fernbankmuseum.org

The Atlanta History Center www.atlantahistorycenter.com

Augusta
The Augusta Museum of History
www.augustamuseum.org

The National Science Center's Fort Discovery www.nscdiscovery.org

Columbus

The Columbus Museum www.columbusmuseum.com

The National Civil War Naval Museum www.portcolumbus.org

Rome
Chieftains Museum
www.chieftainsmuseum.org

Savannah Ships of the Sea Maritime Museum

www.shipsofthesea.org

Savannah History Museum
www.chsqeorgia.org

Aquarium and Zoo/Atlanta
The Georgia Aquarium

www.georgiaaquarium.org

Zoo Atlanta www.zooatlanta.org

Georgia: At A Glance

State Capital: Atlanta

Georgia Borders: Alabama, Florida, North Carolina, South Carolina, Tennessee,

and the Atlantic Ocean

Population: Approximately 9 million

Highest Point: Brasstown Bald at 4,786 feet above sea level

Lowest Point: Sea level on the coastline

Some Major Cities: Atlanta, Augusta, Columbus, Savannah, Athens, Macon, Rome

Some Famous Georgians

Conrad Aiken (1889–1973) from Savannah, GA; was a Pulitzer Prize winning author.

James E. Carter, Jr. (born 1924) from Plains, GA; is the 39th President of the United States and Nobel Peace Prize winner for promoting human rights.

William J. Hardee (1815–1873) from Camden County, GA; was a famous lieutenant general in the Confederate Army.

Martin Luther King Jr. (1929–1968) from Atlanta, GA; was a clergyman and leader in the African-American Civil Rights movement.

Gladys Knight (born 1944) from Atlanta, GA; is an award winning R & B singer/songwriter and author.

Juliette Gordon Low (1860–1927) from Savannah, GA; was founder of Girl Scouts of the U.S.A.

Otis Redding (1941–1967) from Dawson, GA; was a grammy winning singer.

Julia Roberts (born 1967) from Smyrna, GA; is an Academy award winning actress.

Jack "Jackie" Robinson (1919–1972) from Cairo, GA; was the first African American man to play major league baseball with the Brooklyn Dodgers in 1947.

Alice Walker (born 1944) from Eatonton, GA; is a Pulitzer Prize winning author.

Trisha Yearwood (born 1964) from Monticello, GA; is a grammy winning country singer.

Sunrise over the Chattahoochee River near Roswell, Georgia.

CREDITS

Series Concept and Development

Kate Boehm Jerome

Design

Steve Curtis Design, Inc. (www.SCDchicago.com); Roger Radtke, Todd Nossek

Reviewers and Contributors

Neville Bhada, Southeast Tourism Society; Mary L. Heaton, copy editor; Eric Nyquist, researcher

Photography

Back Cover(a), 27d @ Alex Staroseltsev/Shutterstock; Back Cover(b), 13c @ Greg Henry/Shutterstock; Back Cover(c), 7a @ Condor 36/Shutterstock; Back Cover(d), 18a Courtesy Georgia Department of Economic Development; Back Cover(e), 26c @ Stacey Lynn Payne/Shutterstock; Cover(a), 3b @ Travel Bug/Shutterstock; Cover(b), 2b, 4-5, 13b @ Katherine Welles/Shutterstock; Cover(c), 17b, 21a @ Bob Blanchard/Shutterstock; Cover(d) @ Jeff Kinsey/Shutterstock; Cover(e) @ iofoto/Shutterstock; Cover(f), 3a @ Tomas Pavelka/Shutterstock; Cover(e), 2b @ Beoback Pavelka/Shutterstock; 1b @ iofoto/Shutterstock; 2b @ iofoto/Shutterstock

Illustration

Back Cover, 1, 4, 6 © Jennifer Thermes/Photodisc/Getty Images

Copyright © 2010 Kate Boehm Jerome. All rights reserved. No part of this book may be used or reproduced in any manner without written permission except in the case of brief quotations embodied in critical articles and reviews.

ISBN 978-1-58973-011-3

Library of Congress Catalog Card Number: 2009943361

1 2 3 4 5 6 WPC 15 14 13 12 11 10

Published by Arcadia Publishing

Charleston SC, Chicago IL, Portsmouth NH, San Francisco CA

For all general information contact Arcadia Publishing at:

Telephone 843-853-2070

Fax 843-853-0044

mail sales@arcadiapublishing.com

For Customer Service and Orders:

Toll Free 1-888-313-2665

Visit us on the Internet at www.arcadiapublishing.com